Simon in the moonlight

Gilles Tibo

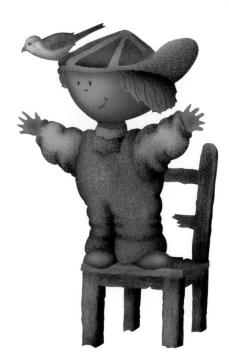

Tundra Books

My name is Simon and I love the moon.

When the moon shines high in the sky
it is a big, bright, beautiful balloon.

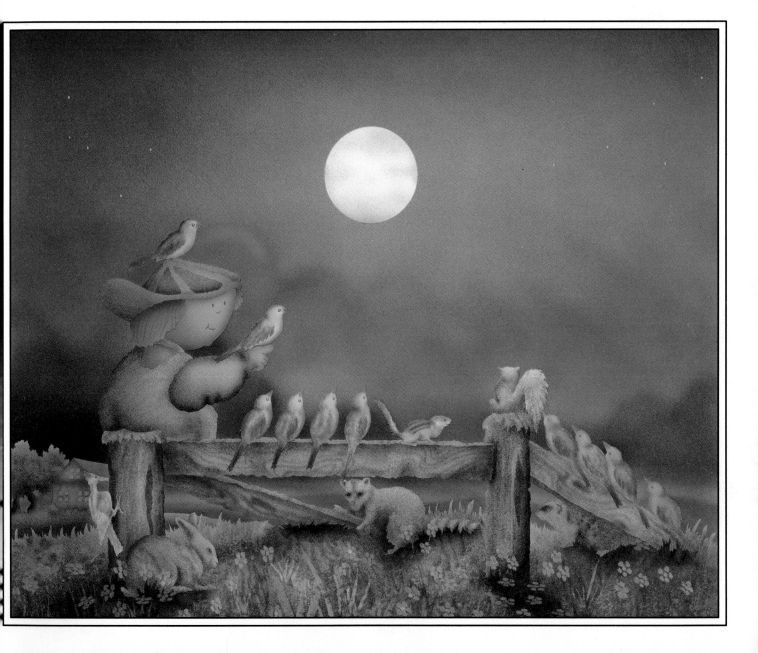

I ride my horse to the top of a hill
to get closer to the moon.

But it does not look the same.
Some of it is missing.

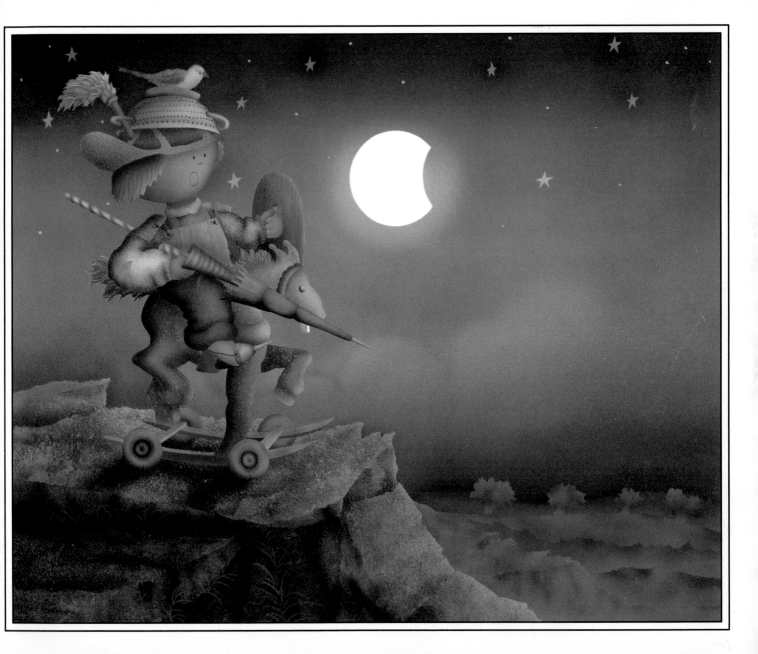

The moon is falling into the lake.
I try to rescue it.

But the lake is too deep.

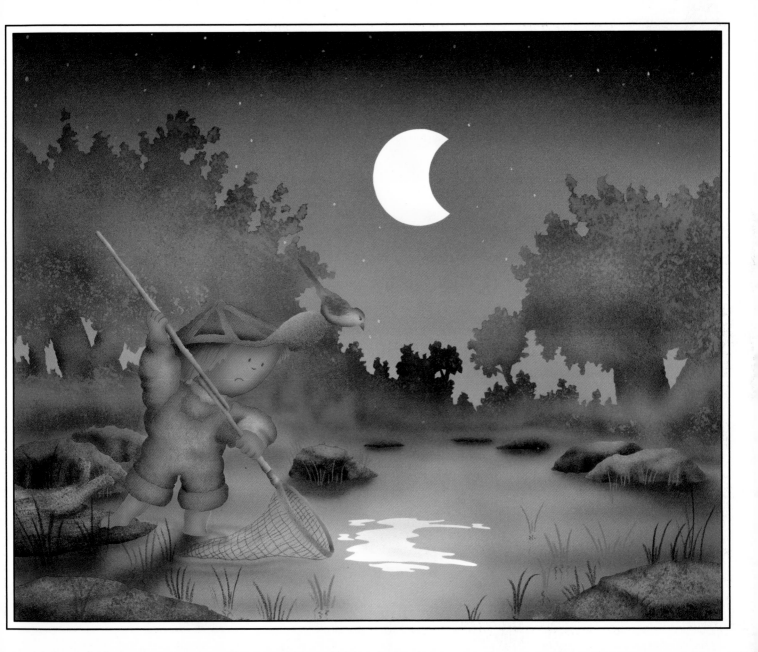

Marlene brings a blanket to catch pieces of the moon.
Nothing falls into our blanket.

But the moon keeps getting smaller.

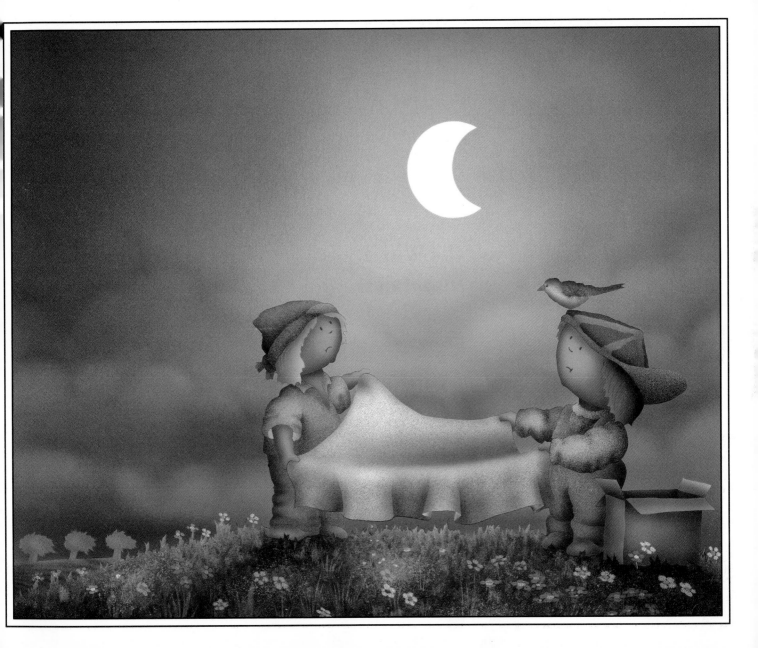

Marlene and I ask the Witch:
"Why is the moon disappearing?"

"I'll go see," she said.
"If I find out, I'll let you know."

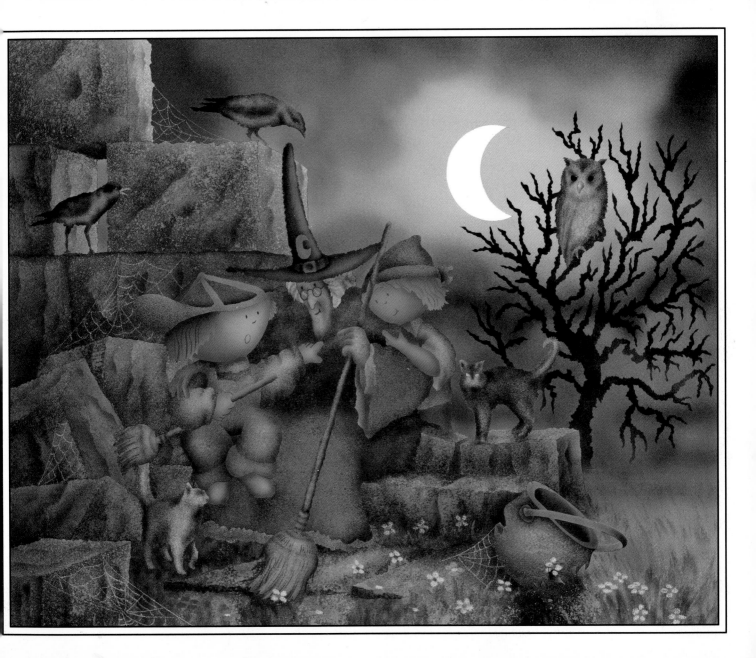

She hops on her broom and flies away.

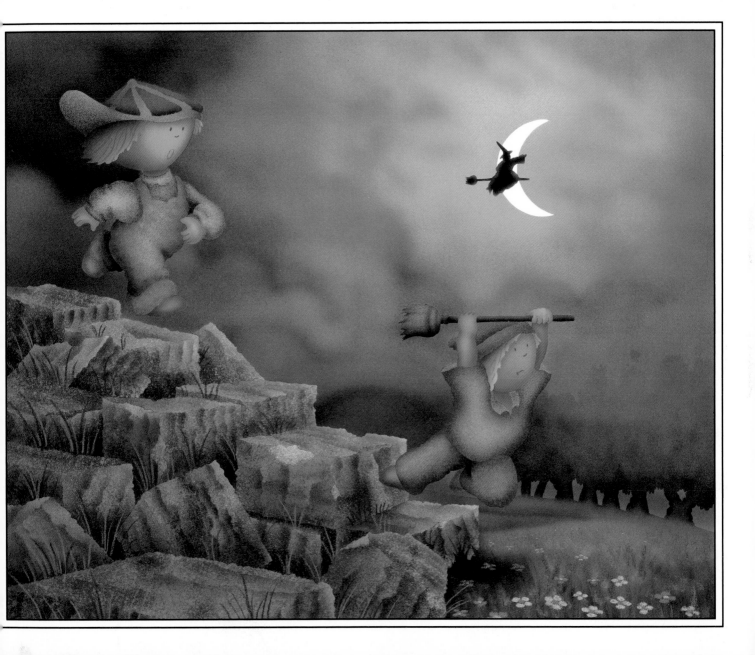

I push Marlene on the swing.
She tries to touch the last piece of the moon.

But the swing is too short.

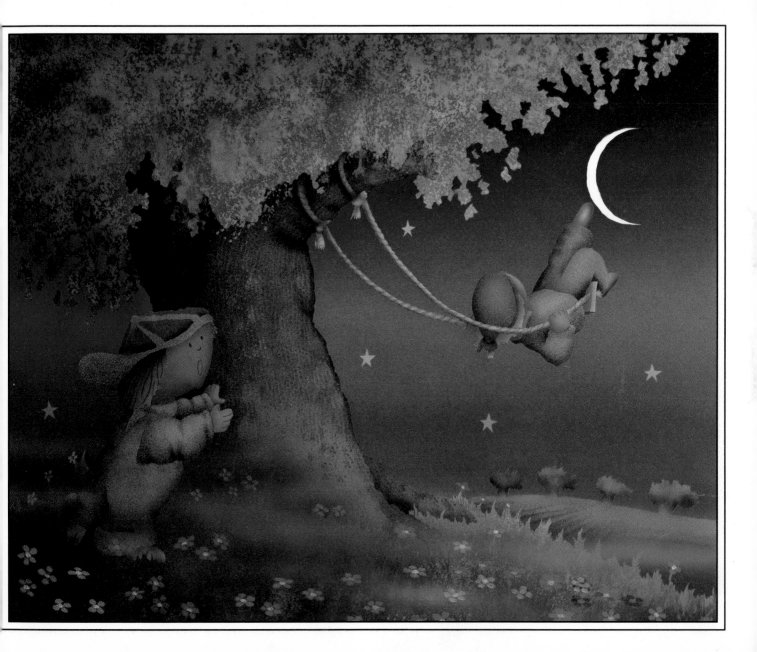

The moon is gone.
I search the sky.
But I cannot find it.

I am alone in the night.

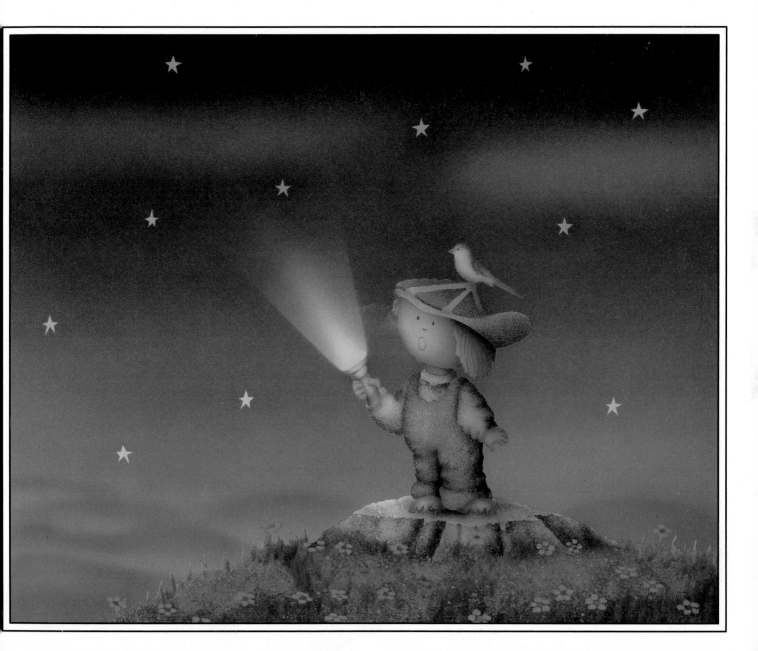

I go to Pierrot who is writing a poem.
"Where has the moon gone?" I ask.

"Oh, it will come back," he said.
"Take my pen and write it a poem."

So I wrote: "Moon, Moon, come back soon.
Come back like a big balloon.
We love you, Moon,
So come back soon."

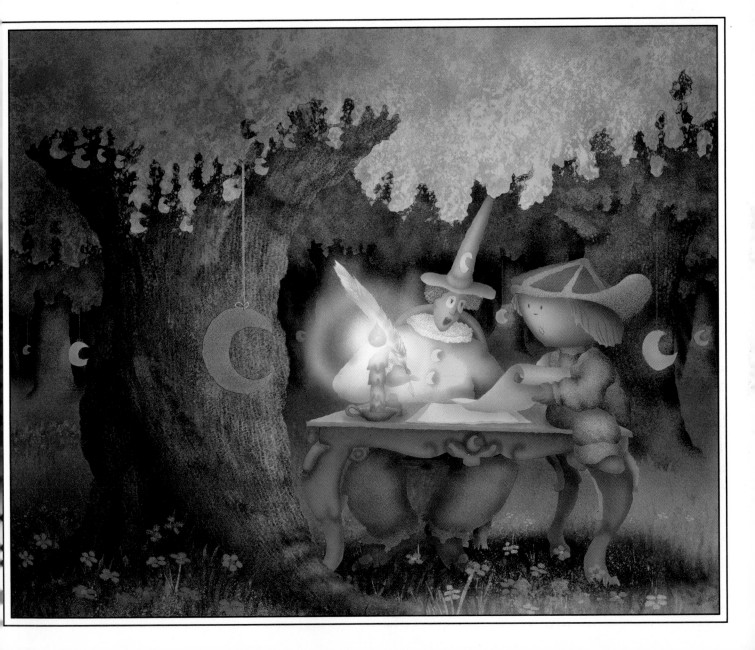

And it did start to come back.

I climb on my chair to call all my friends.

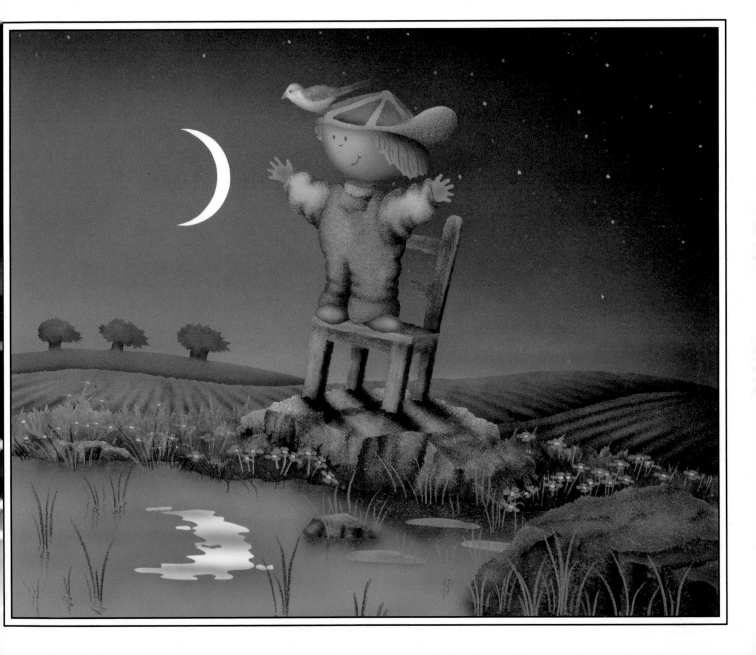

**When the moon is big and bright again,
we all go out to celebrate.**

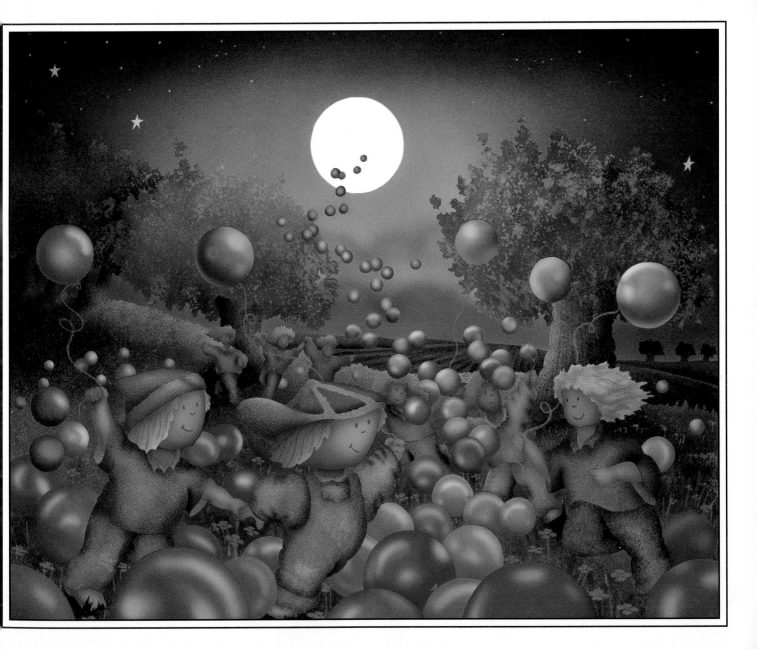

To Anne-Emmanuelle

© 1993, Gilles Tibo

Published in Canada by Tundra Books, Montreal, Quebec H3Z 2N2

Published in the United States by Tundra Books of Northern New York, Plattsburgh, N.Y. 12901

Distributed in the United Kingdom by Ragged Bears Ltd., Andover, Hampshire SP11 9HX

Library of Congress Catalog Number: 93-60334

Canadian Cataloging in Publication Data
Tibo, Gilles, 1951-.
 Simon in the moonlight

ISBN 0-88776-316-2 (hardcover) 10 9 8 7 6 5 4 3 2 1
ISBN 0-88776-347-2 (paperback) 10 9 8 7 6 5 4 3 2 1

[Issued also in French under title: *Simon au clair de lune* ISBN 0-88776-348-0]

 I. Title. II. Title: Simon au clair de lune. English.

PS8589.I26S4513 1993 jC843'.54 C93-090202-5
PZ7.T43Si 1993

Printed in Hong Kong by South China Printing Co. Ltd.

A special edition printed for

Troll Book Clubs